DRAWING
FLOWERS

VICTOR PERARD

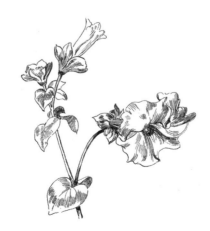

DOVER PUBLICATIONS, INC.
MINEOLA, NEW YORK

Bibliographical Note

This Dover edition, first published in 2008, is an unabridged republication of the work originally published in 1958 by the Pitman Publishing Corporation, New York.

Library of Congress Cataloging-in-Publication Data

Pérard, Victor Semon, 1870–1957.
 Drawing flowers / Victor Perard.
 p. cm.
 Originally published: New York : Pitman Publishing Corporation, 1958.
 ISBN-13: 978-0-486-46909-6
 ISBN-10: 0-486-46909-3
 1. Flowers in art. 2. Drawing—Technique. I. Title.

NC815.P4 2008
743'.73—dc22

2008023947

Manufactured in the United States of America
Dover Publications, Inc., 31 East 2nd Street, Mineola, N.Y. 11501

FOREWORD

Flowers are graceful and delicate. Their form and coloring are varied and demonstrate a most surprising vigor or, at the opposite extreme, an exquisite lightness. Drawing flowers will help an artist develop a sense of composition and an eye for rhythmic balance of design, both of which are very important in any artist's training. To draw flowers of many sorts, and yet to maintain their individual characteristics, obliges the student to draw with care as well as trains the eye and hand to coordinate in order to achieve the best results. The correct rendering of a flower is a severe test, but the necessity of close observation well repays any effort involved.

Before attempting to draw any flowers, you must obtain the right materials to work with. They are an H. B. and a B. B. B. drawing pencil, a rubber eraser, a pliable pen, a small camel's-hair brush, some black ink, and a pad of paper eight by twelve inches in size. More art materials than these at the start will lead only to confusion and prevent skillfulness in any medium. It is better to use a few mediums proficiently than to use many, but none well.

Treat your art materials with respect: take good care of them. Drawings should be made neatly and look professional. They can be begun with the H. B. pencil, which makes a light line. This way any mistake is easily corrected by erasing. To use the dark B. B. B. pencil too soon may ruin your picture because its lines are not easily erased. A heavy dark line is not only impressed on the paper, but it also is impressed in your mind and makes it difficult to imagine the composition in any way other than that already on the paper. Keep all the preliminary lines light.

Before touching pencil to paper, plan your work; try to visualize what you intend to draw and the style of technique that you intend to use. Learn to select the principal lines of the subject and sketch them in lightly first. The details will fall into place with ease. The first lines made are usually the most important, and the last ones are of least value.

The feeling for art goes to waste unless it is backed by knowledge, and knowledge is acquired only through study and continual practice. To draw correctly is less a natural gift than the result of good training. Often talented students are outclassed by those with less natural talent but with more method and application.

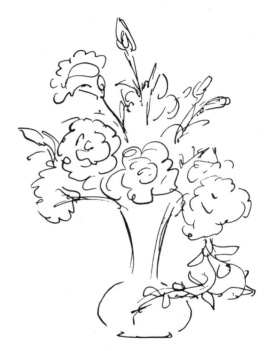

Place the long lines
first, and fill in later.

Preliminary sketch

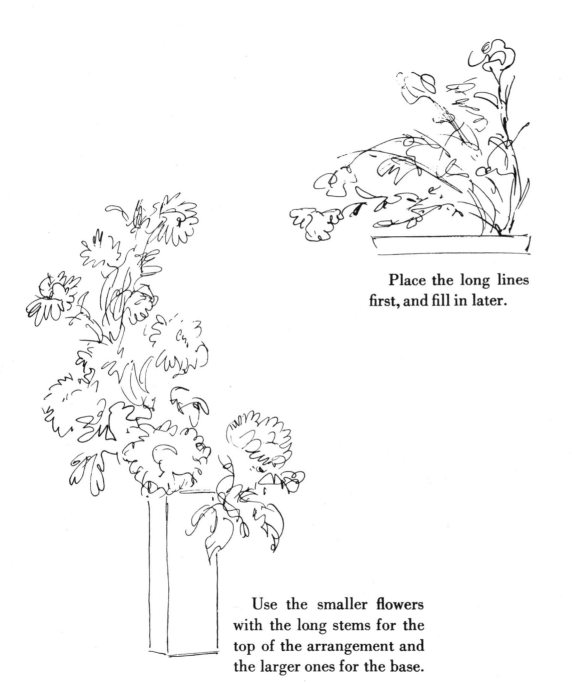

Use the smaller flowers
with the long stems for the
top of the arrangement and
the larger ones for the base.

It is a good practice to
make a rough sketch of the
proposed grouping. A few
preliminary lines will save a
lot of fussing.

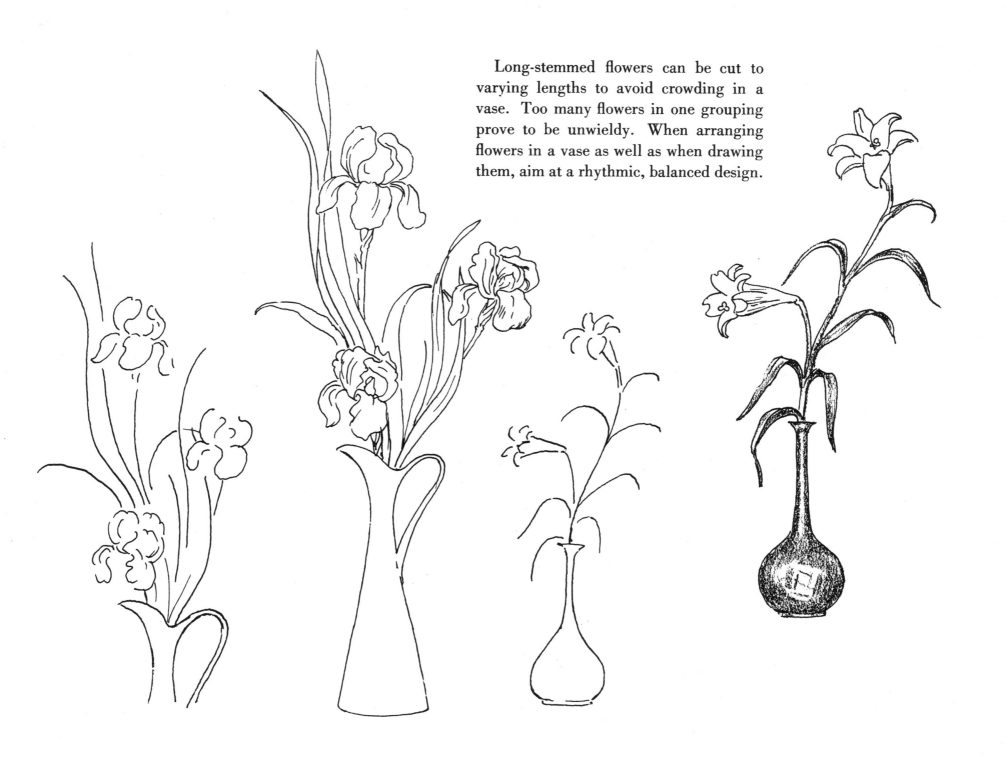

Long-stemmed flowers can be cut to varying lengths to avoid crowding in a vase. Too many flowers in one grouping prove to be unwieldy. When arranging flowers in a vase as well as when drawing them, aim at a rhythmic, balanced design.

Flowers with a gracefully
bent stem can be an aid in
good compositions.

Coax a stem to
bend as needed.

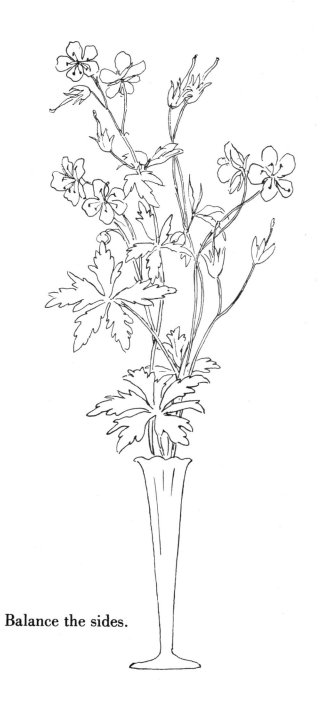

Balance the sides.

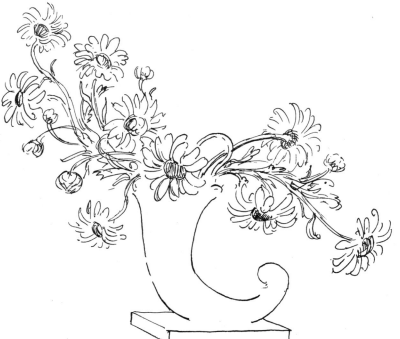

Evening primroses

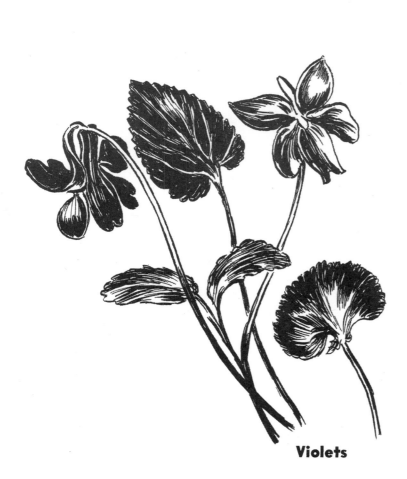

Violets

Daisies

An appreciation of masses and contours can be gained by resorting frequently to ink drawings in silhouette.

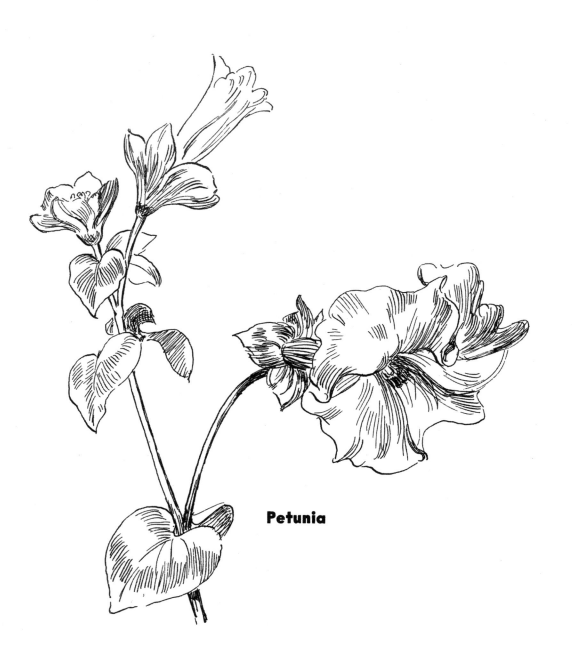

Petunia

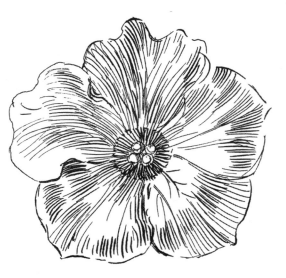

Front view of a petunia

For exercise in the handling of a pen, copy these flower studies.

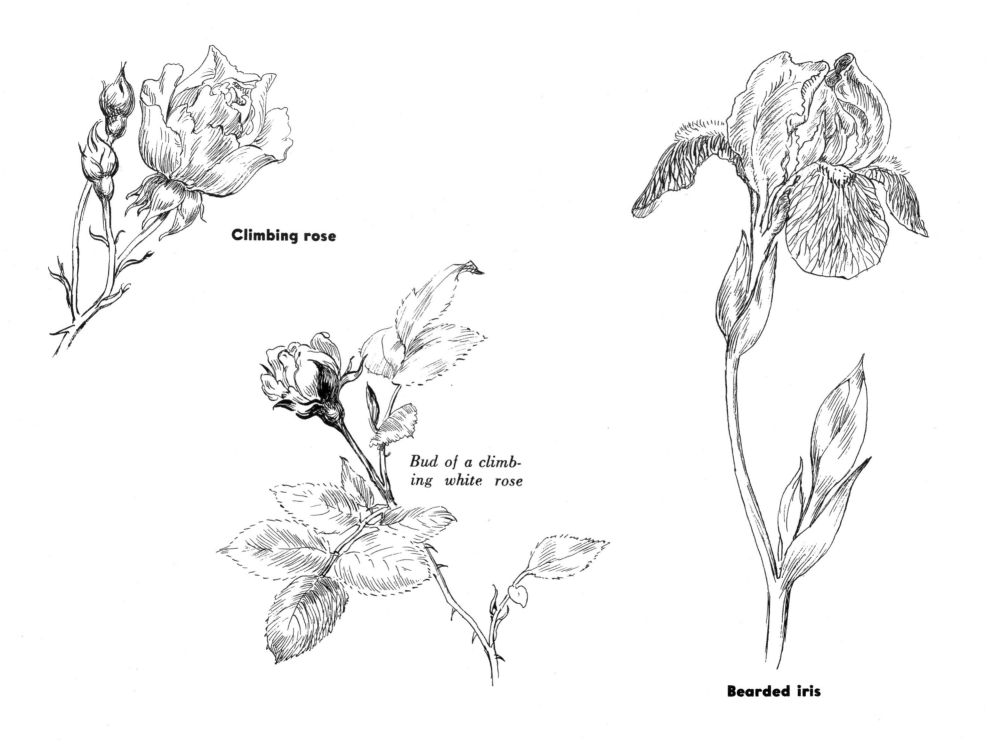

Climbing rose

Bud of a climbing white rose

Bearded iris

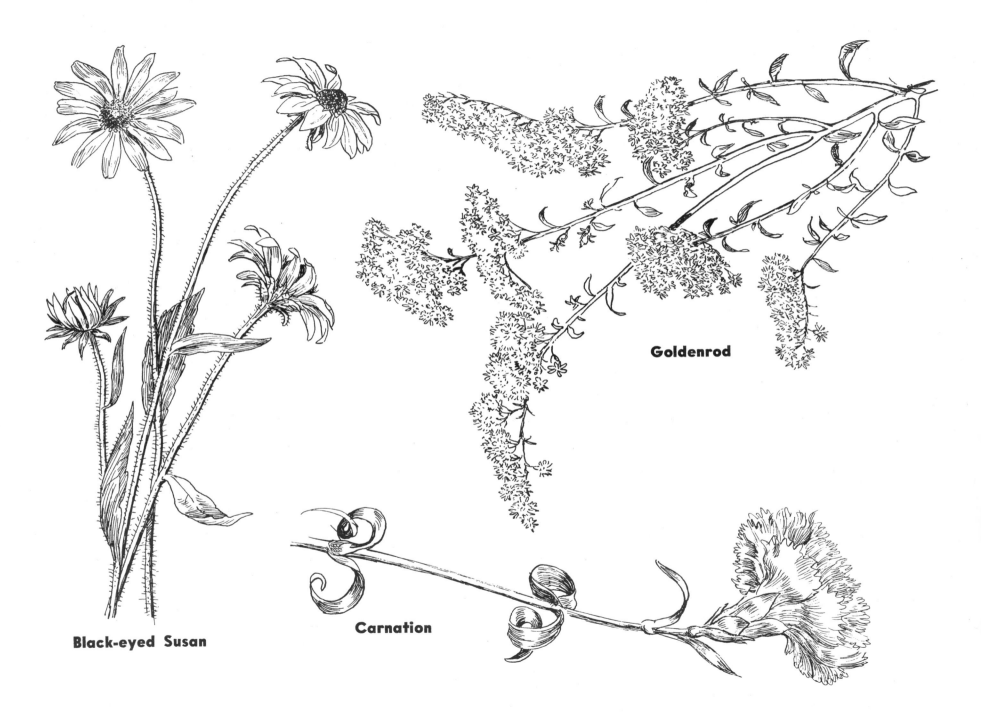

Black-eyed Susan

Carnation

Goldenrod

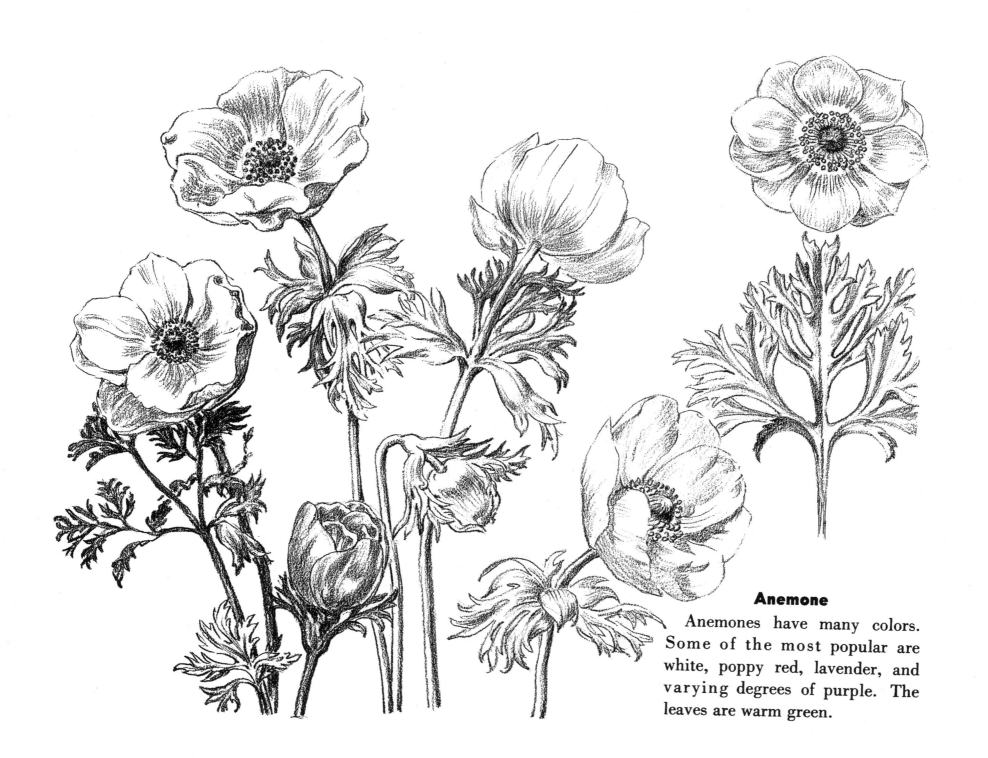

Anemone

Anemones have many colors. Some of the most popular are white, poppy red, lavender, and varying degrees of purple. The leaves are warm green.

Aster

There are several species of asters native to North America. Among these are the China aster, the purple-flowered New England aster and the golden aster. The leaves are deep green. These flowers resemble stars and so derive their name from the Greek word "aster," meaning star.

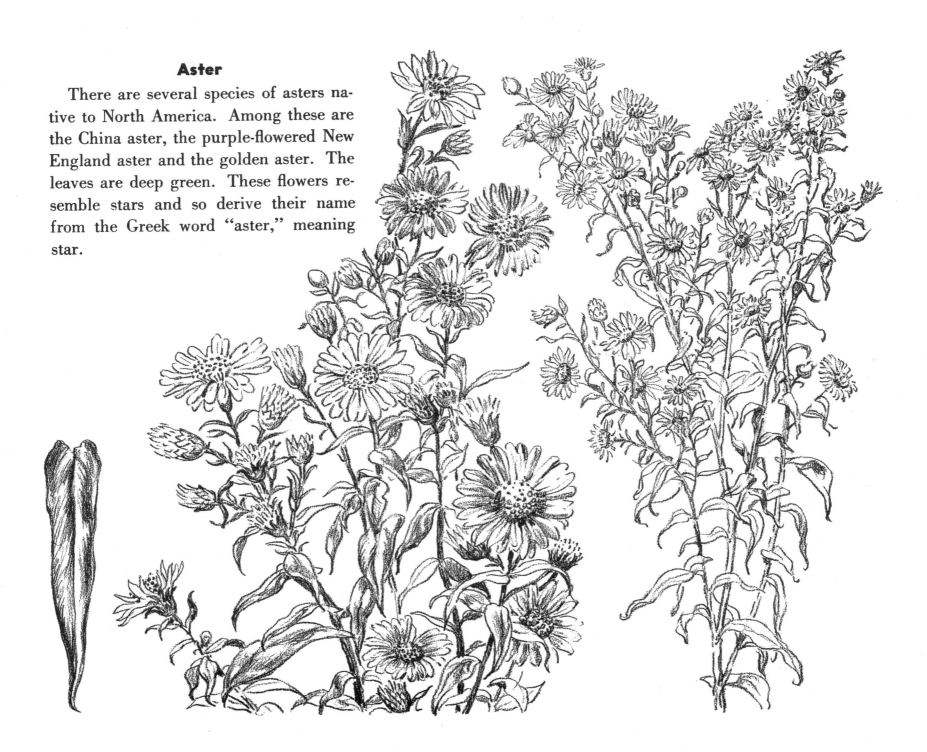

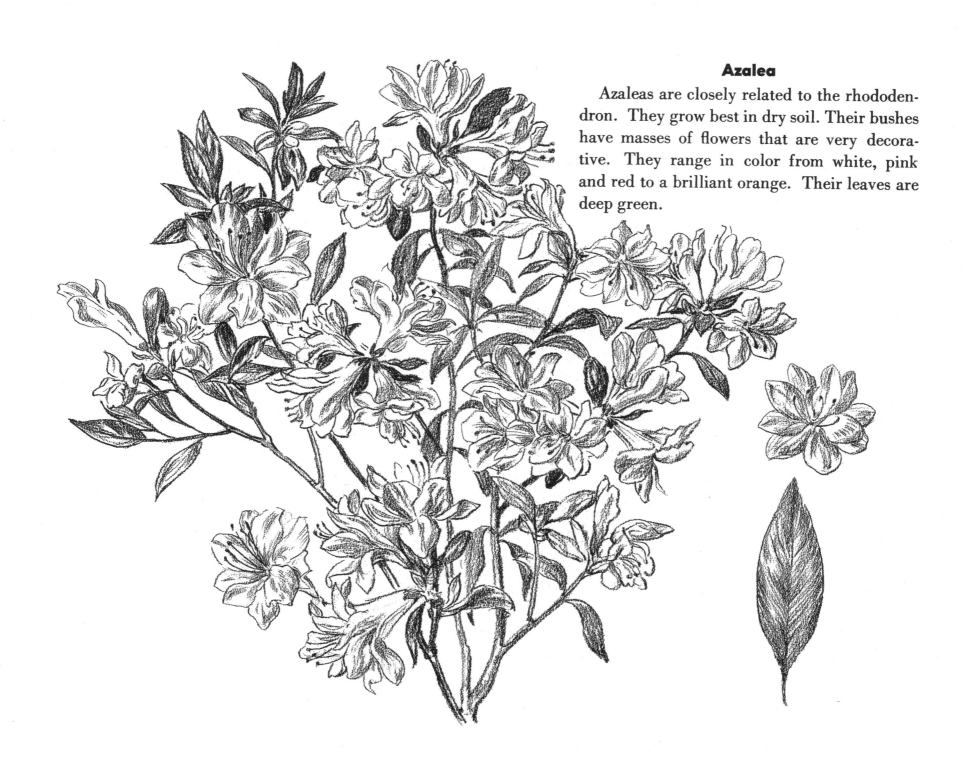

Azalea

Azaleas are closely related to the rhododendron. They grow best in dry soil. Their bushes have masses of flowers that are very decorative. They range in color from white, pink and red to a brilliant orange. Their leaves are deep green.

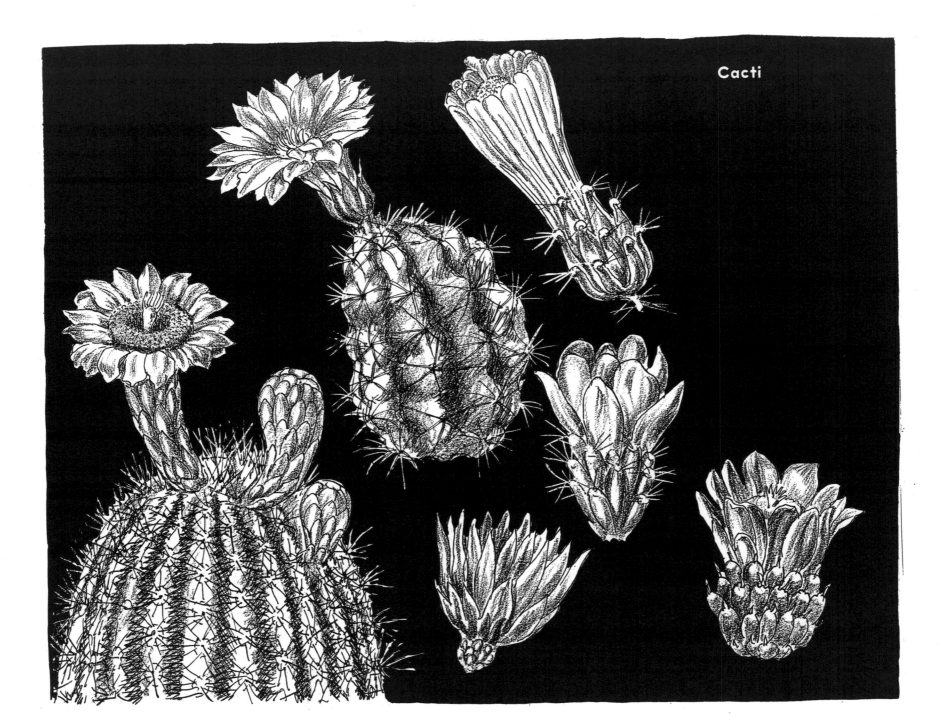

Cacti

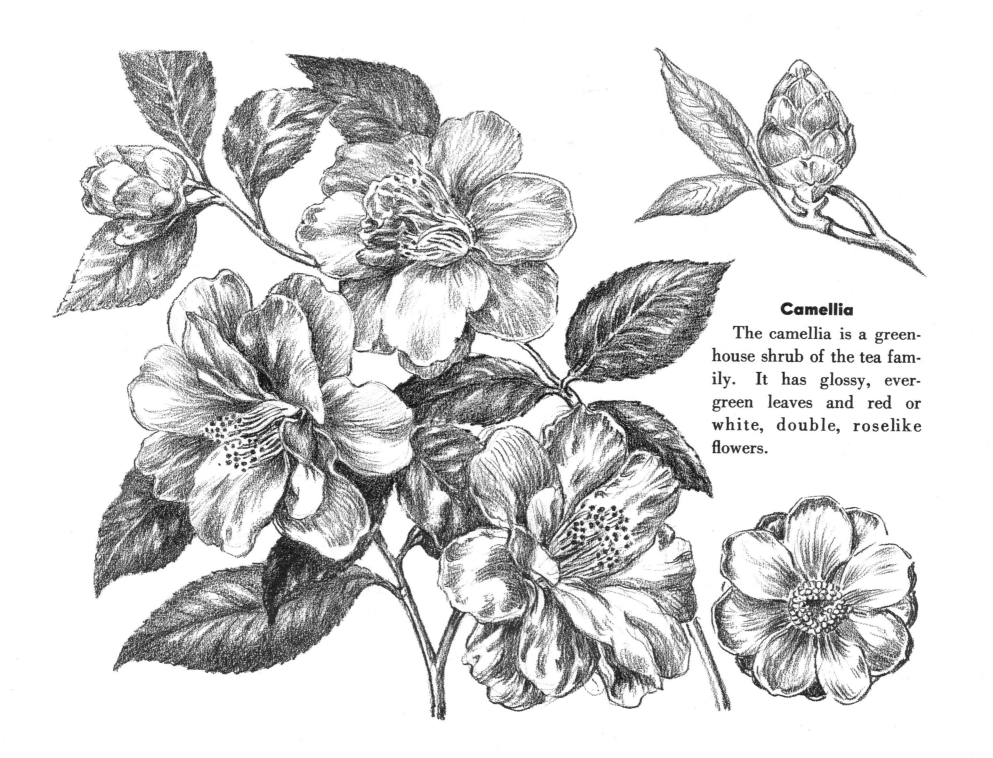

Camellia

The camellia is a greenhouse shrub of the tea family. It has glossy, evergreen leaves and red or white, double, roselike flowers.

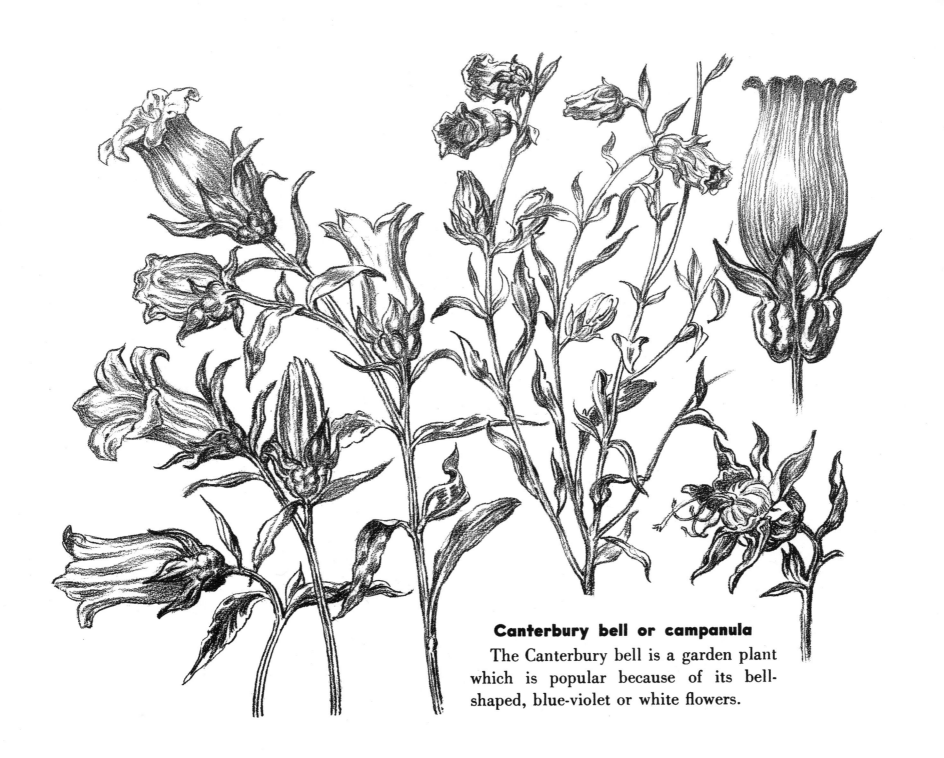

Canterbury bell or campanula

The Canterbury bell is a garden plant which is popular because of its bell-shaped, blue-violet or white flowers.

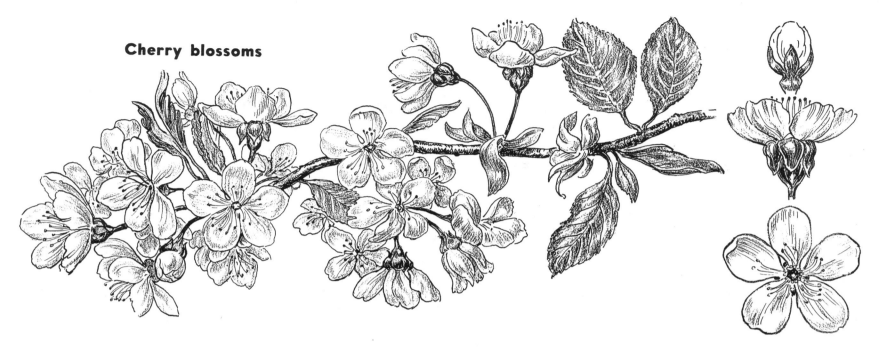

Cherry blossoms

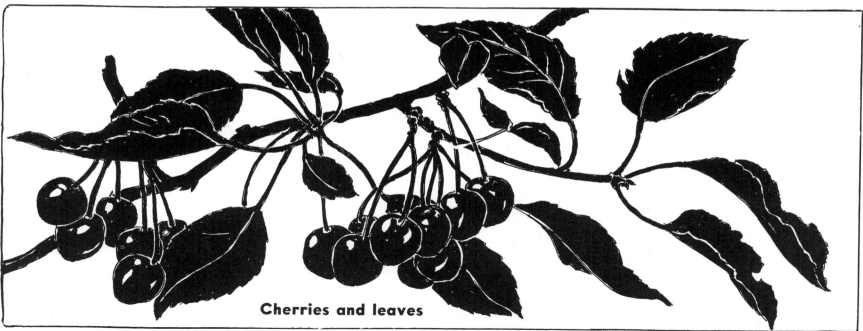

Cherries and leaves

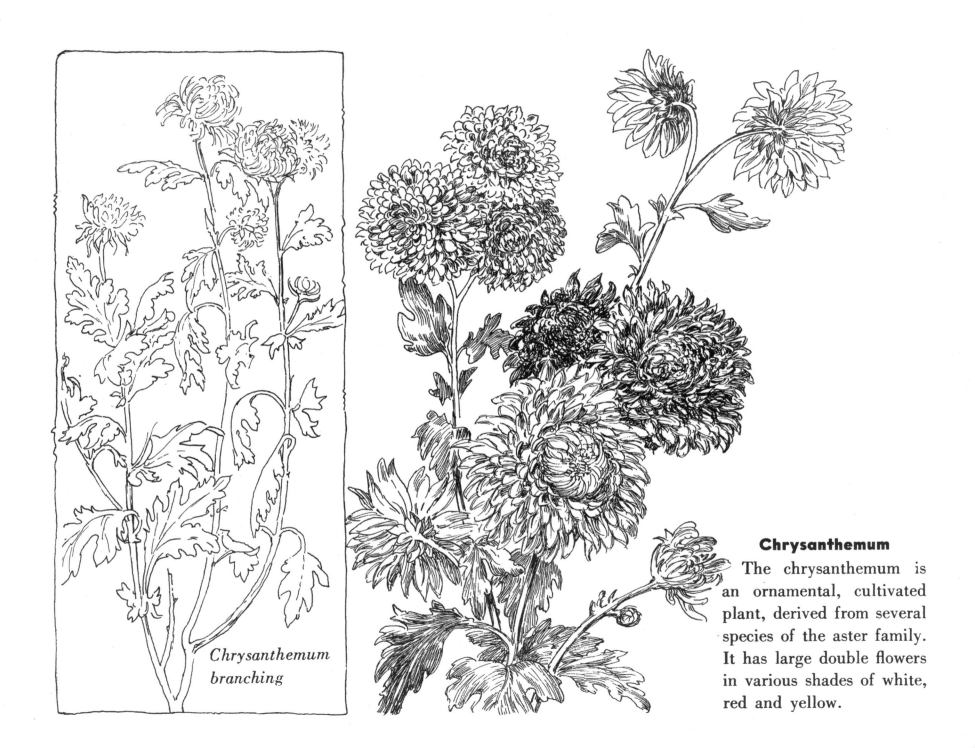

Chrysanthemum branching

Chrysanthemum

The chrysanthemum is an ornamental, cultivated plant, derived from several species of the aster family. It has large double flowers in various shades of white, red and yellow.

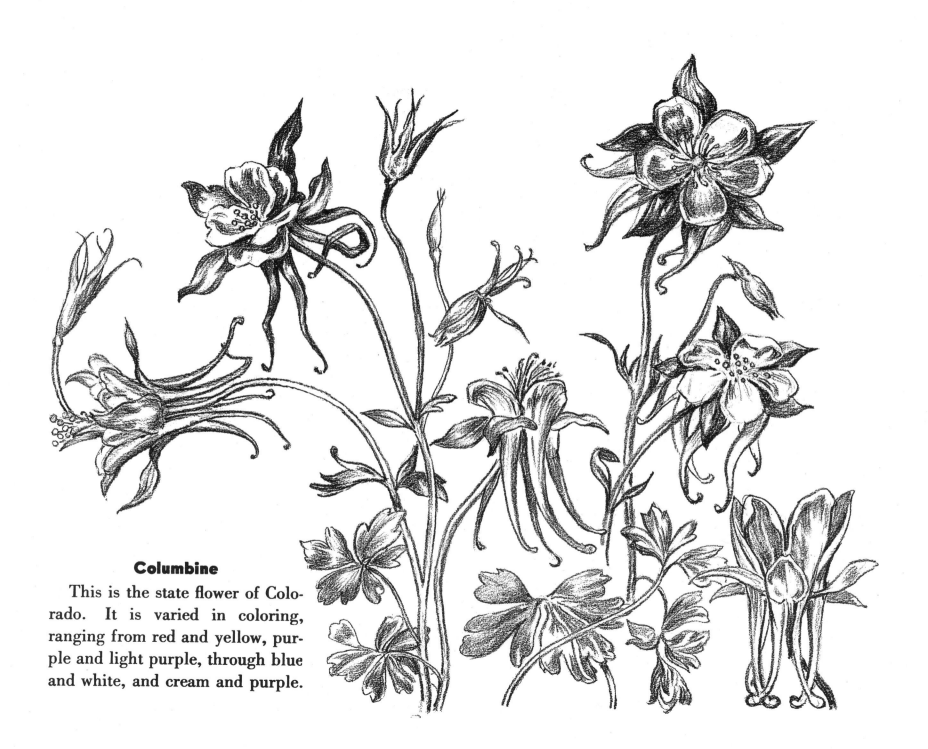

Columbine

This is the state flower of Colorado. It is varied in coloring, ranging from red and yellow, purple and light purple, through blue and white, and cream and purple.

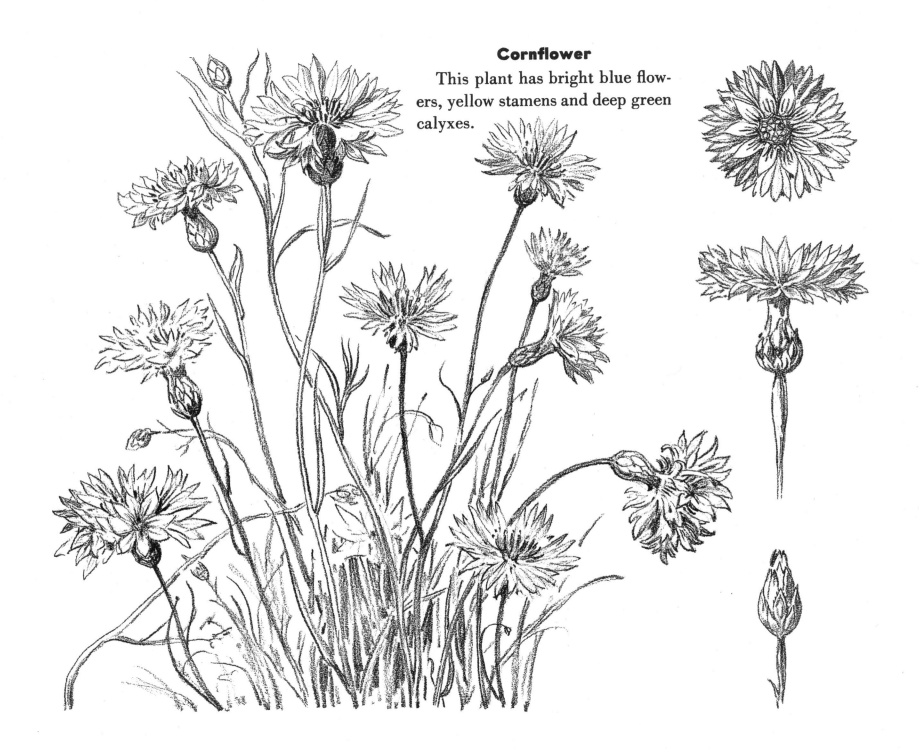

Cornflower

This plant has bright blue flowers, yellow stamens and deep green calyxes.

Daffodils and narcissi

Daffodils are among the early Spring
flowers, and are of the same family as the
narcissi. Daffodils are a brilliant yellow.
Both flowers are very decorative, and are
easily adapted to design.

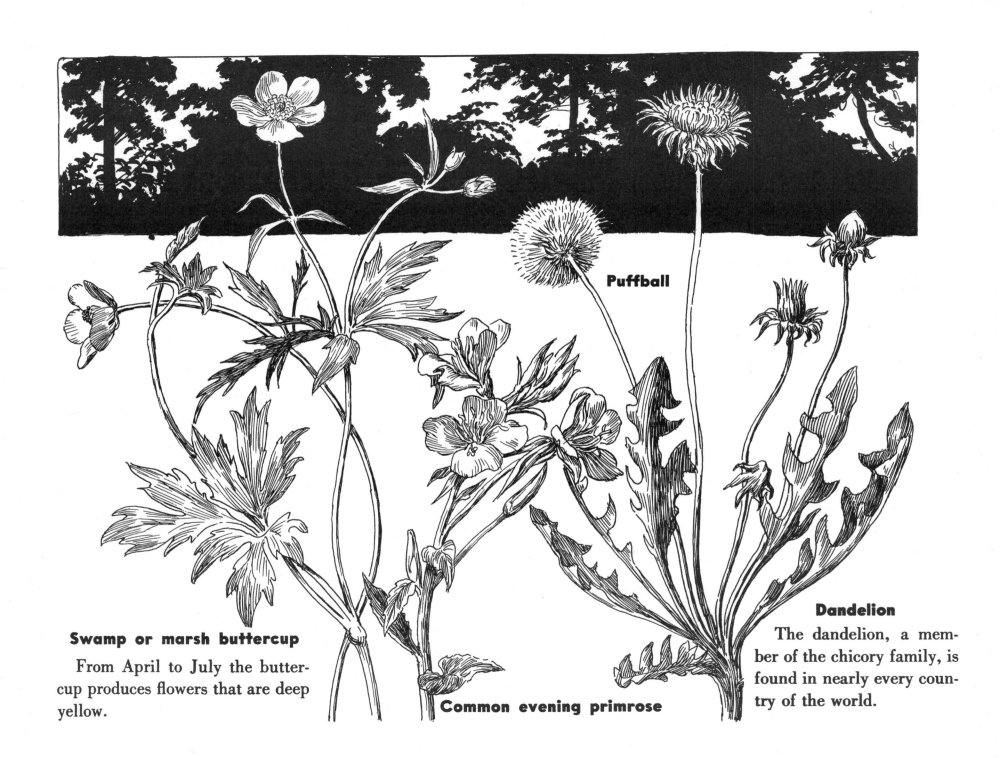

Puffball

Swamp or marsh buttercup

From April to July the buttercup produces flowers that are deep yellow.

Common evening primrose

Dandelion

The dandelion, a member of the chicory family, is found in nearly every country of the world.

Dusty miller

This gray-green garden plant gets its name from the fact that its leaves are seemingly coated with flour.

Fern in silhouette

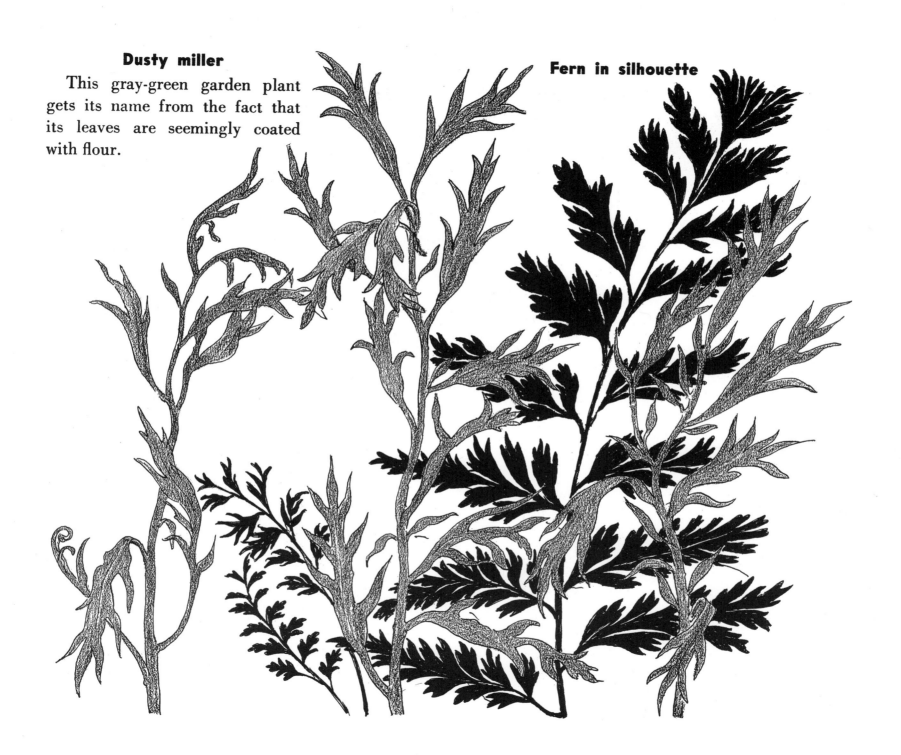

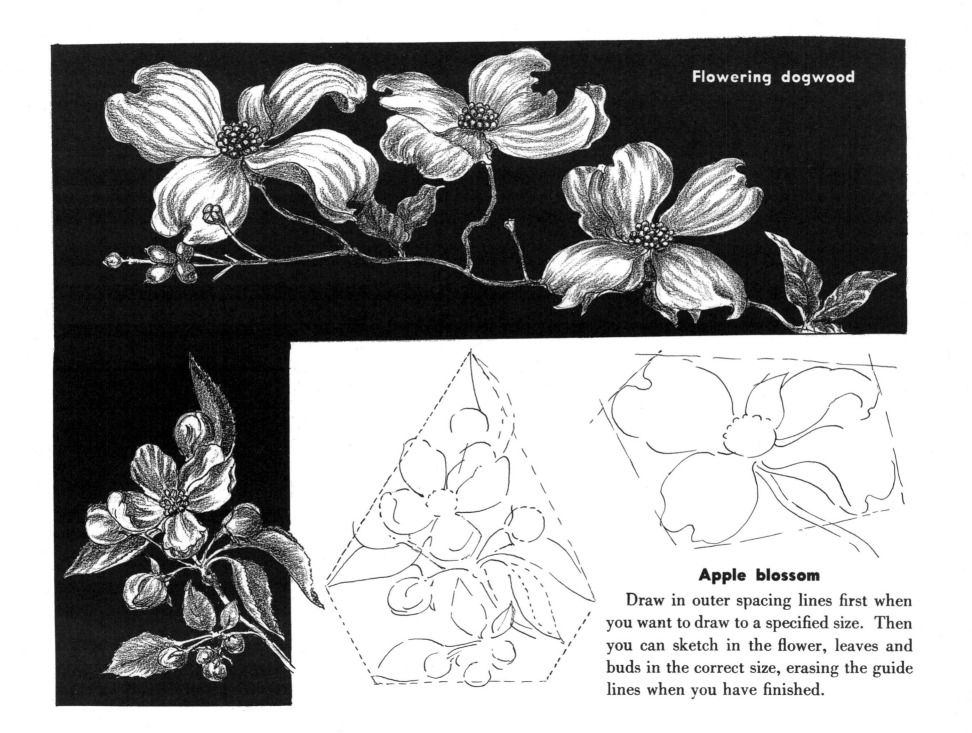

Flowering dogwood

Apple blossom

Draw in outer spacing lines first when you want to draw to a specified size. Then you can sketch in the flower, leaves and buds in the correct size, erasing the guide lines when you have finished.

A drawing well prepared is half done.

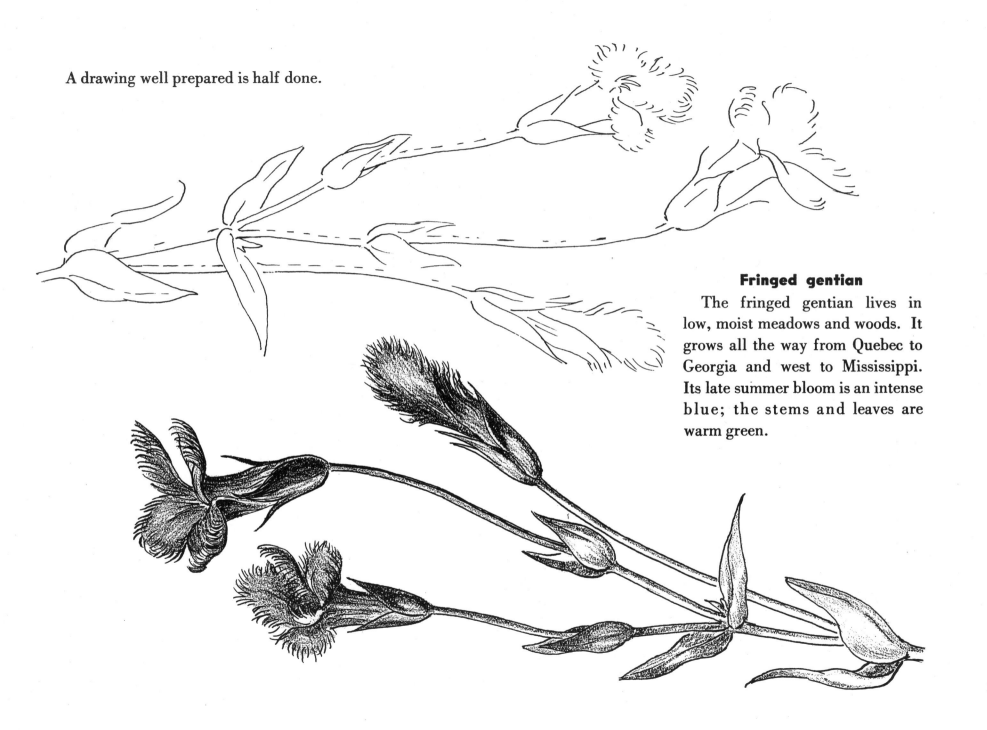

Fringed gentian

The fringed gentian lives in low, moist meadows and woods. It grows all the way from Quebec to Georgia and west to Mississippi. Its late summer bloom is an intense blue; the stems and leaves are warm green.

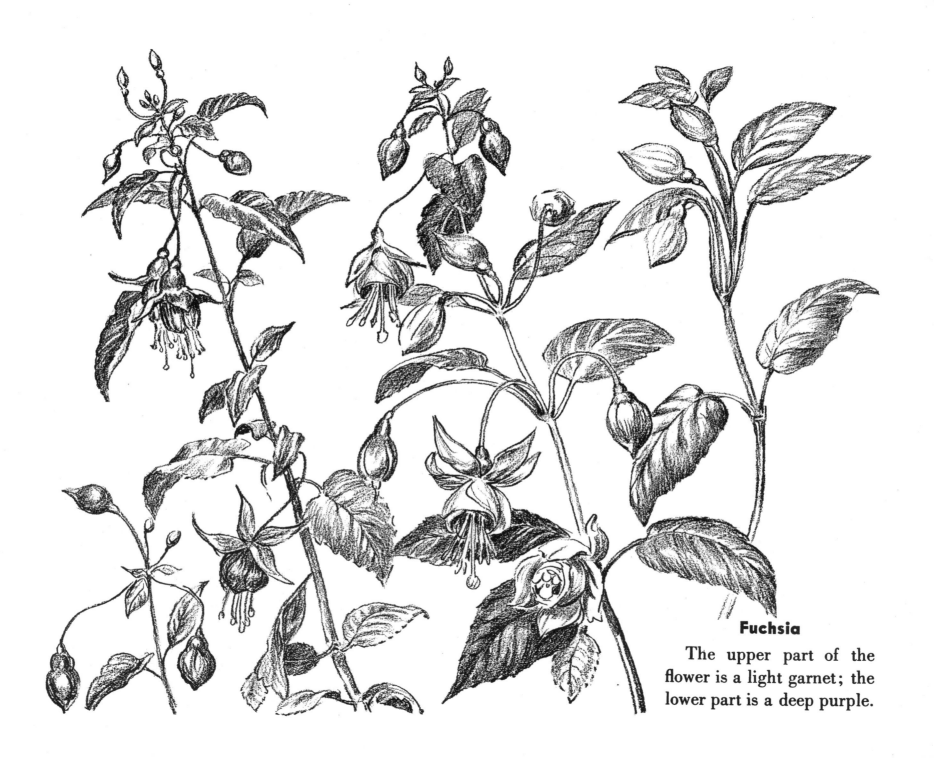

Fuchsia

The upper part of the flower is a light garnet; the lower part is a deep purple.

Geranium

The geranium grows in temperate zones. The flowers are white, red or pink, and the leaves are deep green.

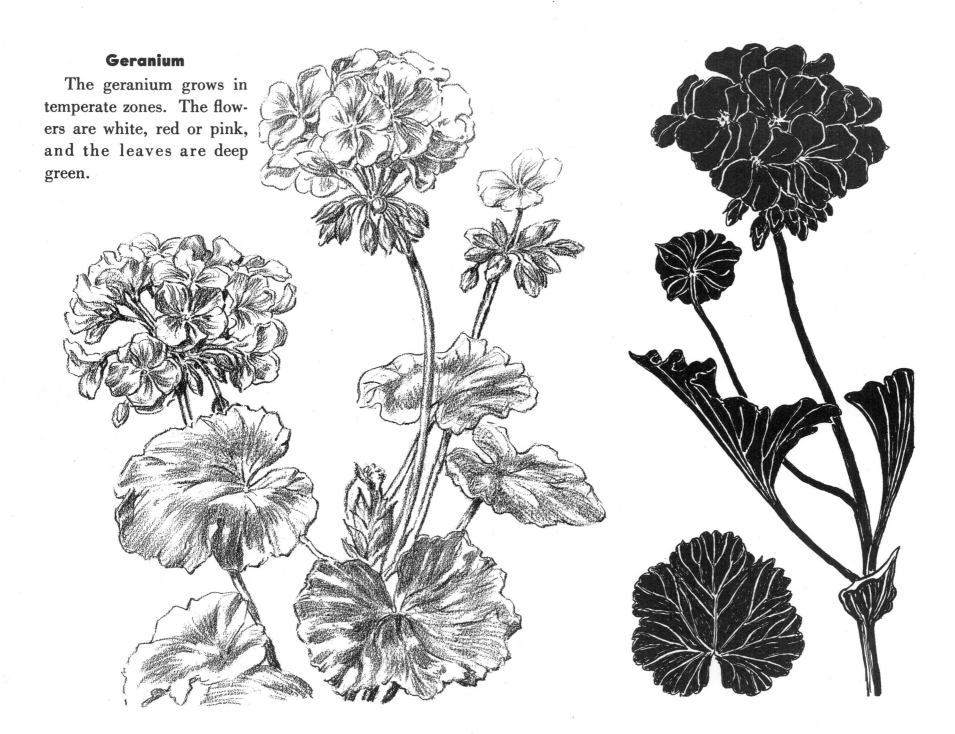

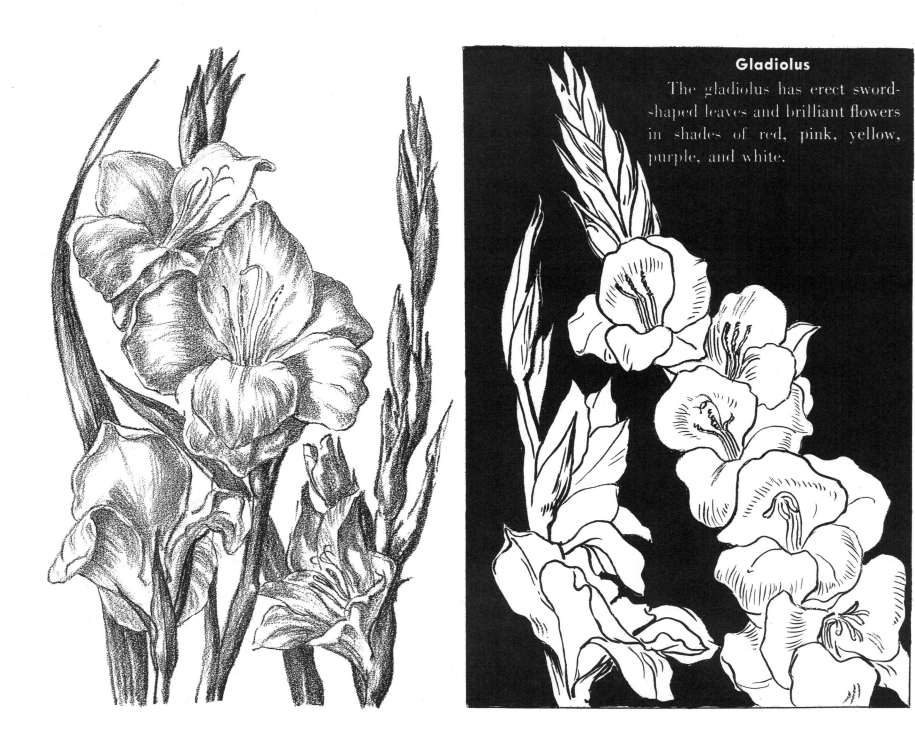

Gladiolus

The gladiolus has erect sword-shaped leaves and brilliant flowers in shades of red, pink, yellow, purple, and white.

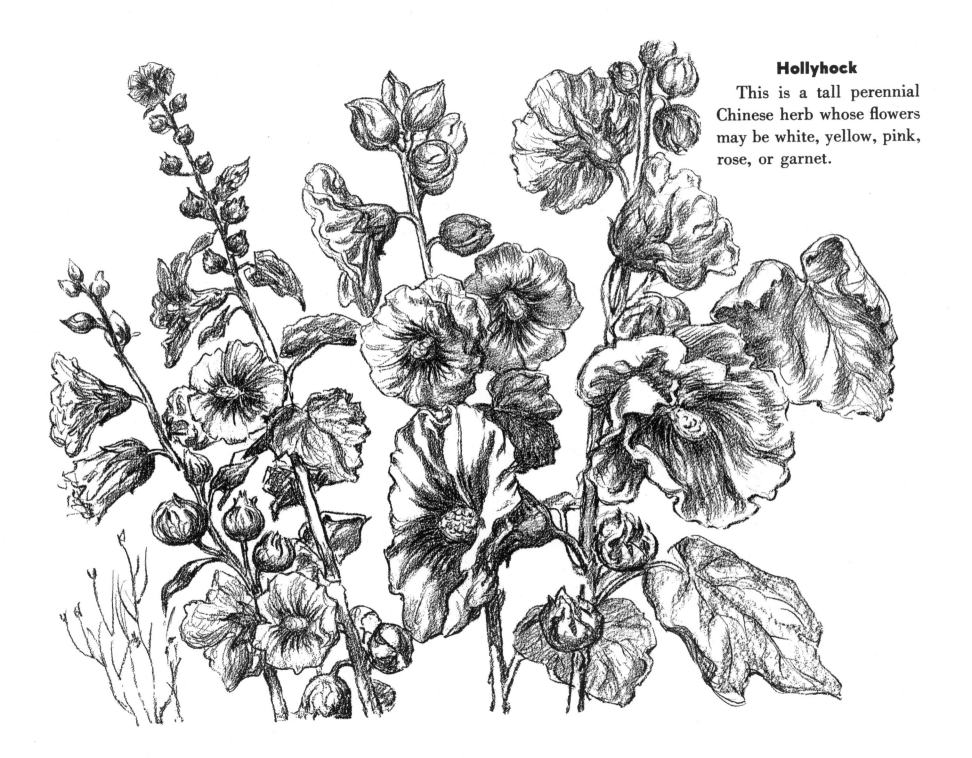

Hollyhock

This is a tall perennial Chinese herb whose flowers may be white, yellow, pink, rose, or garnet.

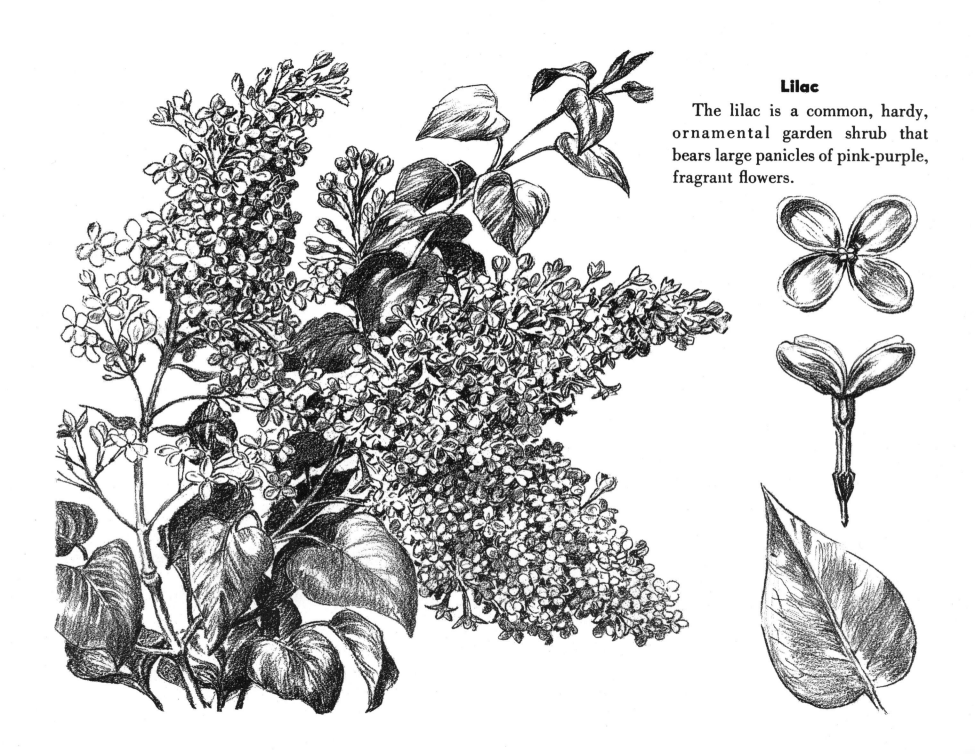

Lilac

The lilac is a common, hardy, ornamental garden shrub that bears large panicles of pink-purple, fragrant flowers.

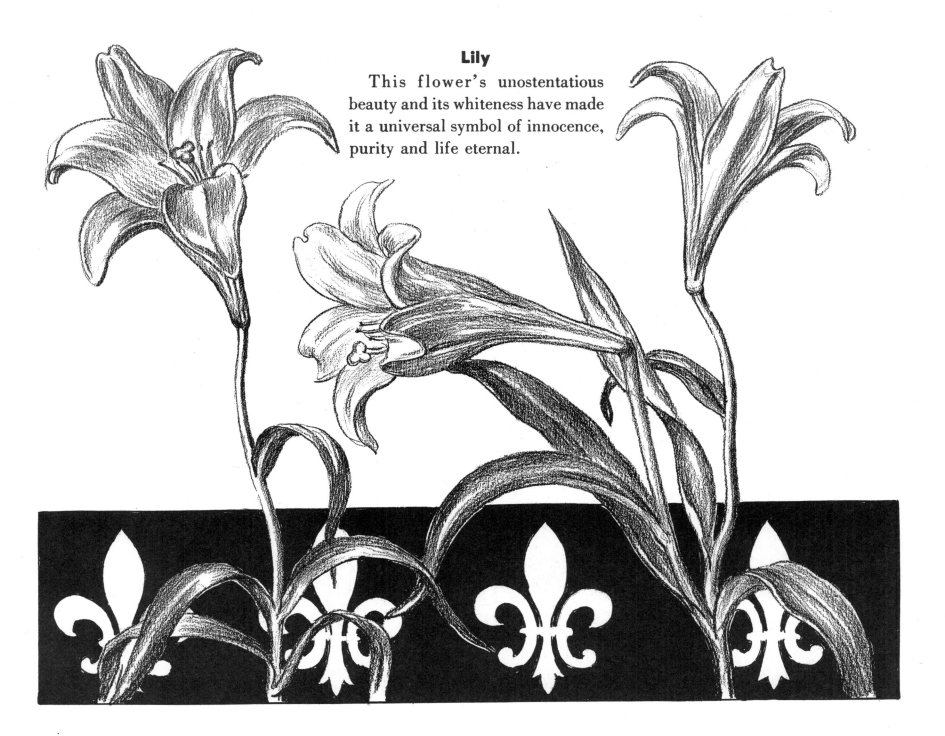

Lily

This flower's unostentatious beauty and its whiteness have made it a universal symbol of innocence, purity and life eternal.

Magnolia

The magnolia is a genus of trees having aromatic bark and large, fragrant, white, pink, or purple flowers. The rich, glossy, green leaves are light brown on their undersides.

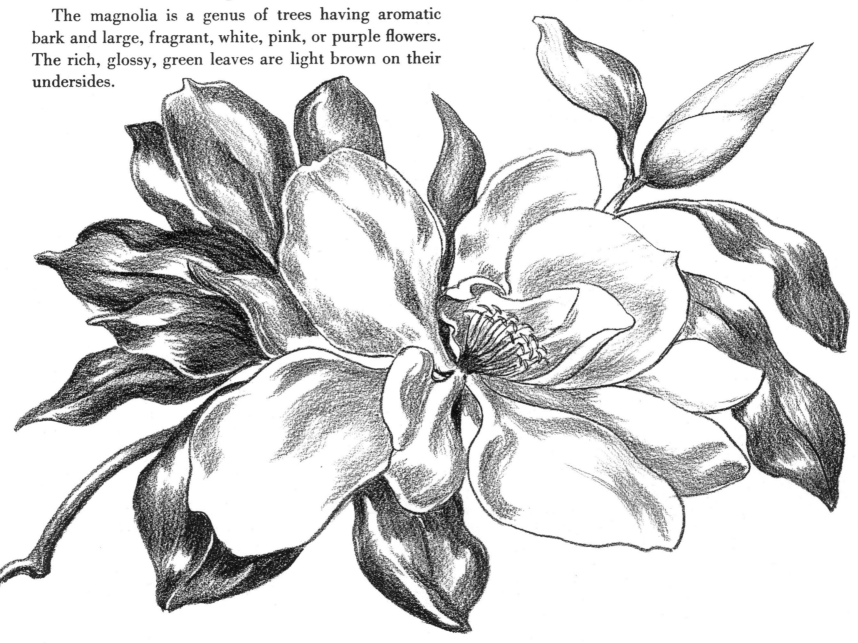

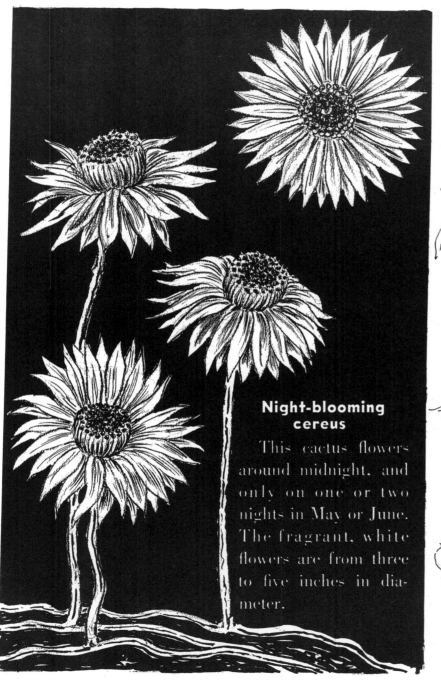

Night-blooming cereus

This cactus flowers around midnight, and only on one or two nights in May or June. The fragrant, white flowers are from three to five inches in diameter.

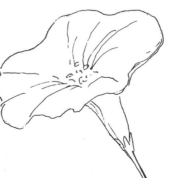

Morning-glory

This pen and ink drawing is characteristic of many charming studies that can be done in a loose style first and elaborated into a complete picture.

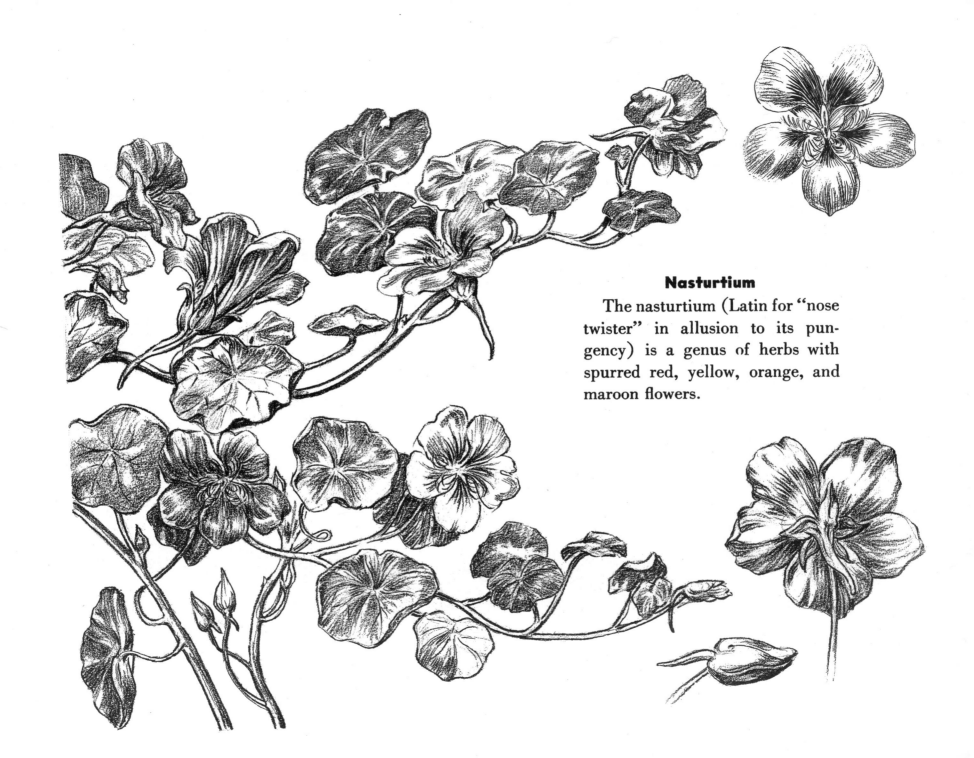

Nasturtium

The nasturtium (Latin for "nose twister" in allusion to its pungency) is a genus of herbs with spurred red, yellow, orange, and maroon flowers.

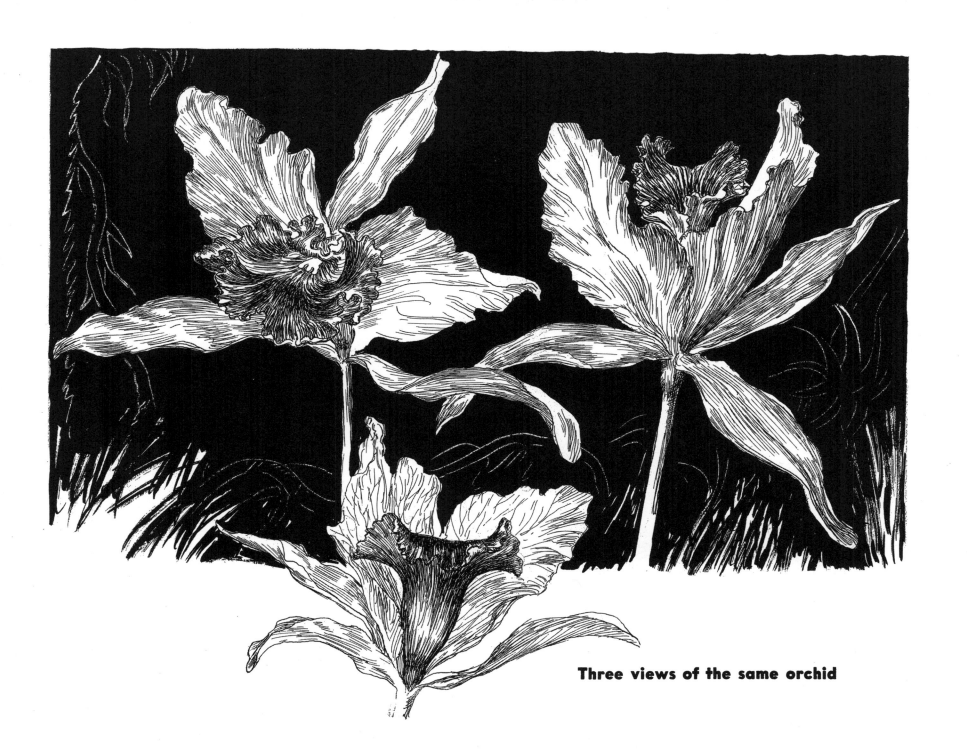

Three views of the same orchid

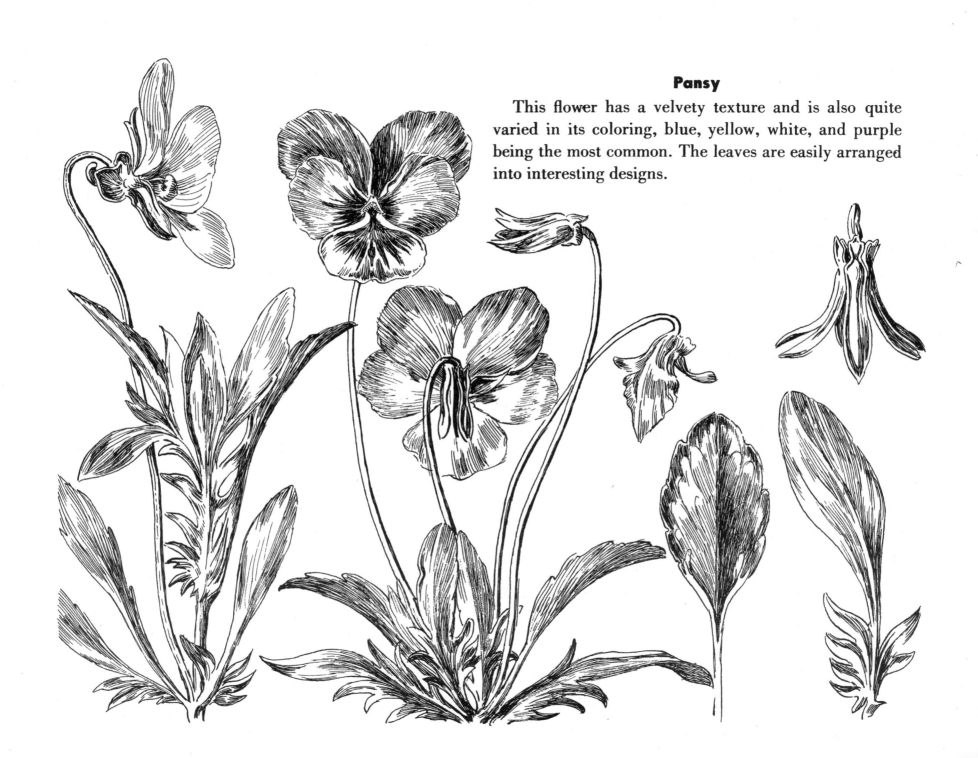

Pansy

This flower has a velvety texture and is also quite varied in its coloring, blue, yellow, white, and purple being the most common. The leaves are easily arranged into interesting designs.

Poinsettia

This plant's small green flower and large red leaves make it very popular at Christmas.

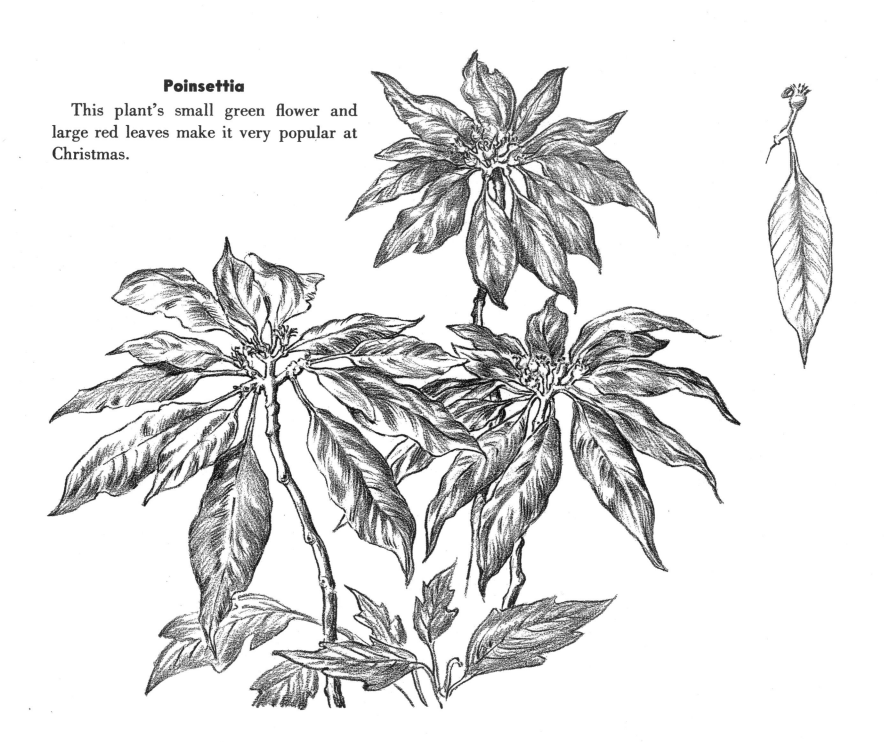

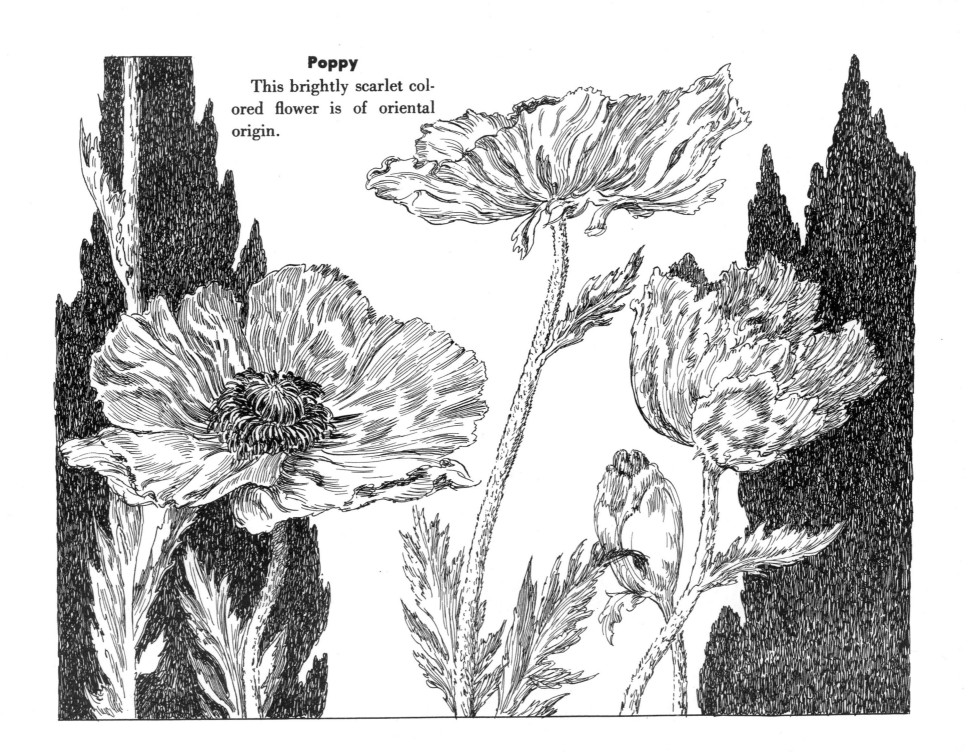

Poppy

This brightly scarlet colored flower is of oriental origin.

Red spruce

Holly leaves are a
deep, glossy green; its
berries are a bright red.

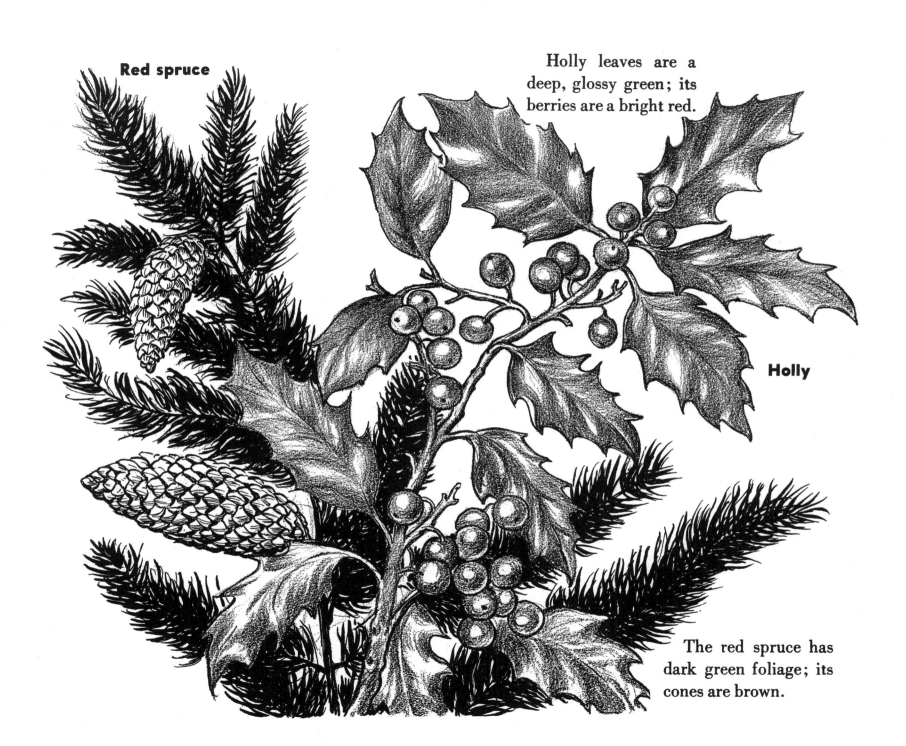

Holly

The red spruce has
dark green foliage; its
cones are brown.

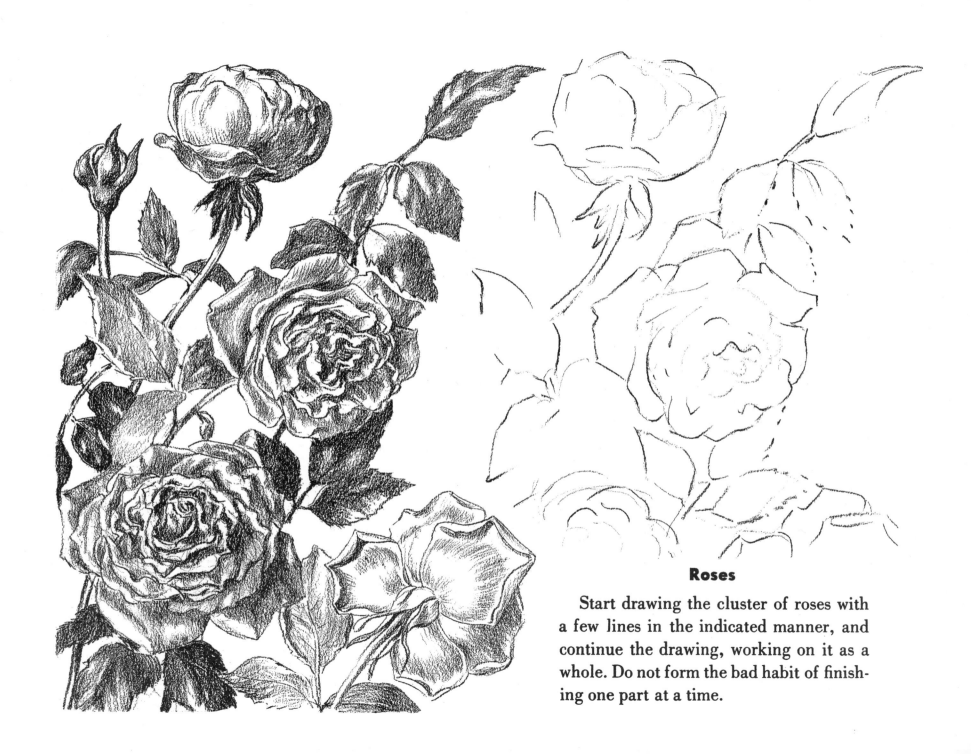

Roses

Start drawing the cluster of roses with a few lines in the indicated manner, and continue the drawing, working on it as a whole. Do not form the bad habit of finishing one part at a time.

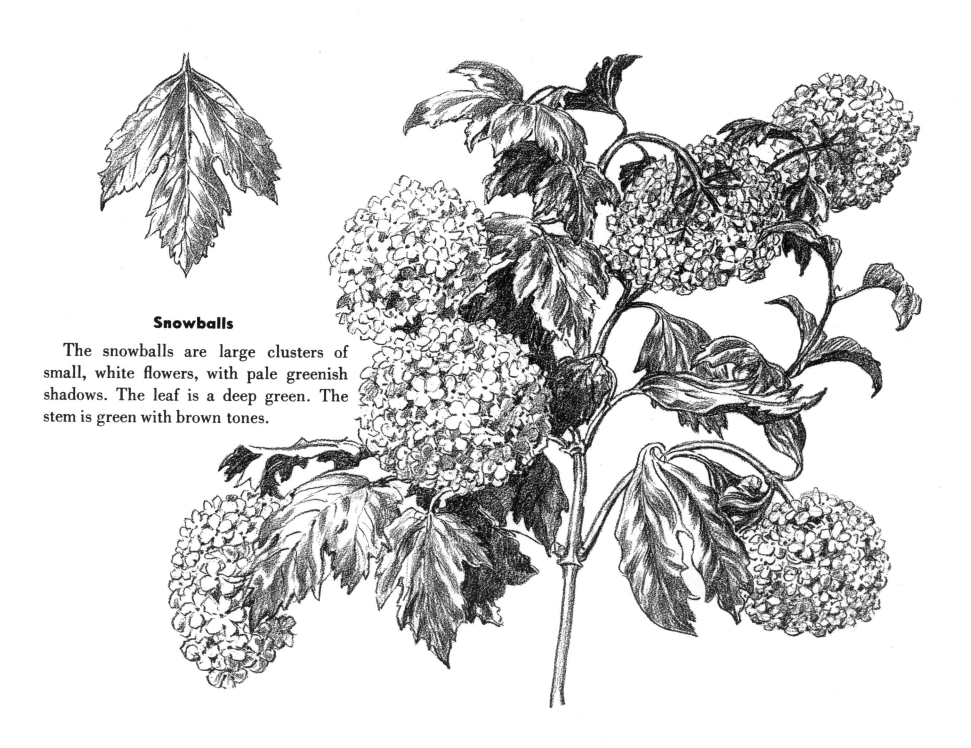

Snowballs

The snowballs are large clusters of small, white flowers, with pale greenish shadows. The leaf is a deep green. The stem is green with brown tones.

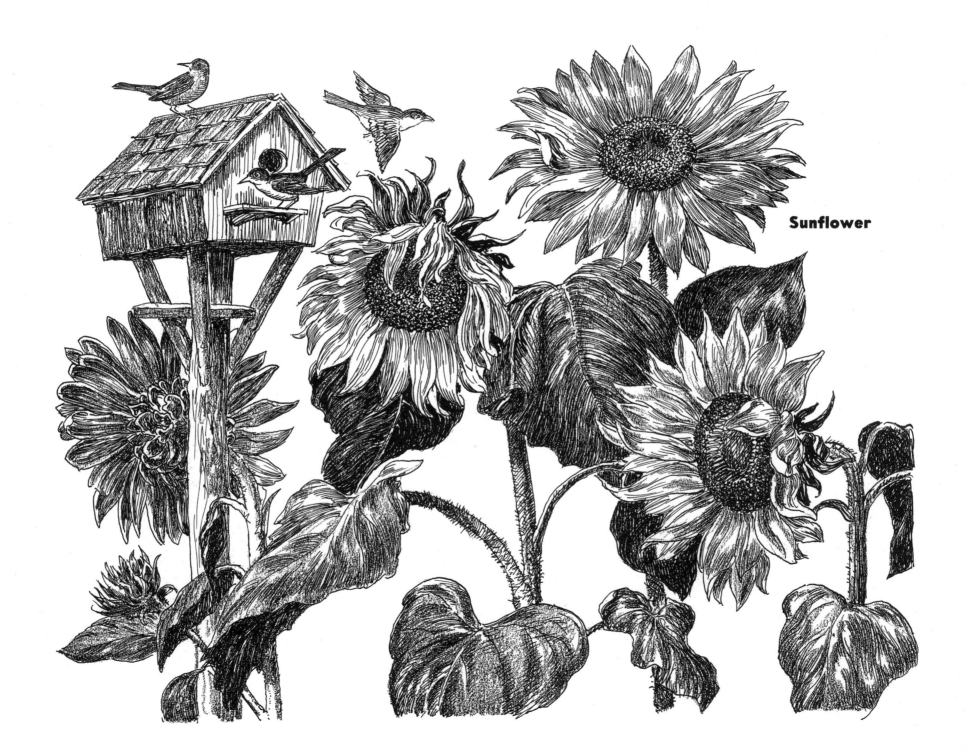

Sunflower

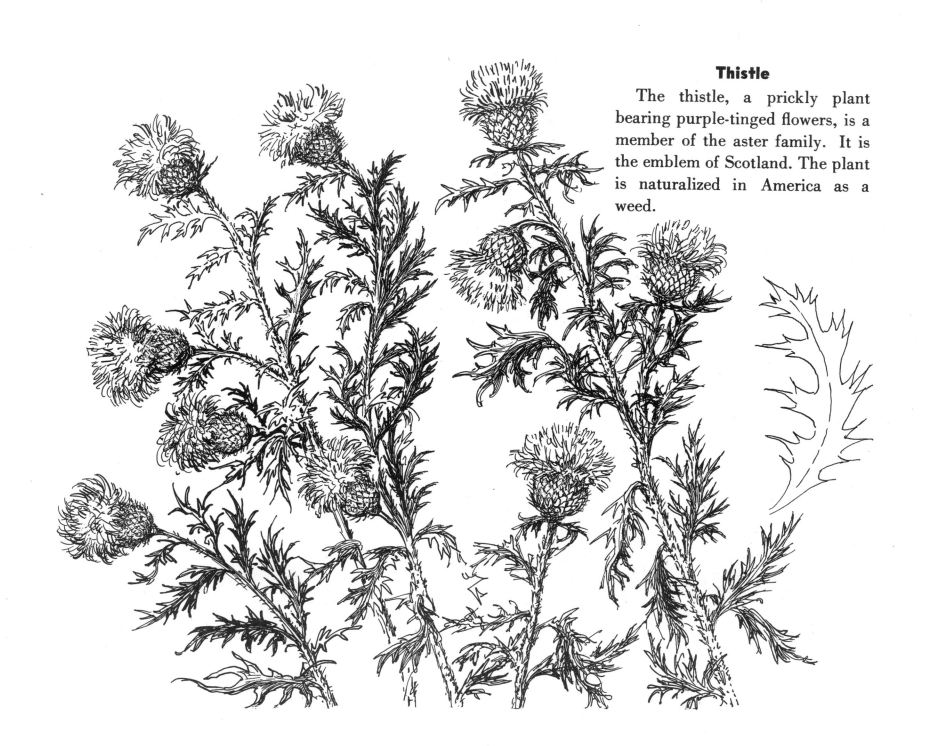

Thistle

The thistle, a prickly plant bearing purple-tinged flowers, is a member of the aster family. It is the emblem of Scotland. The plant is naturalized in America as a weed.

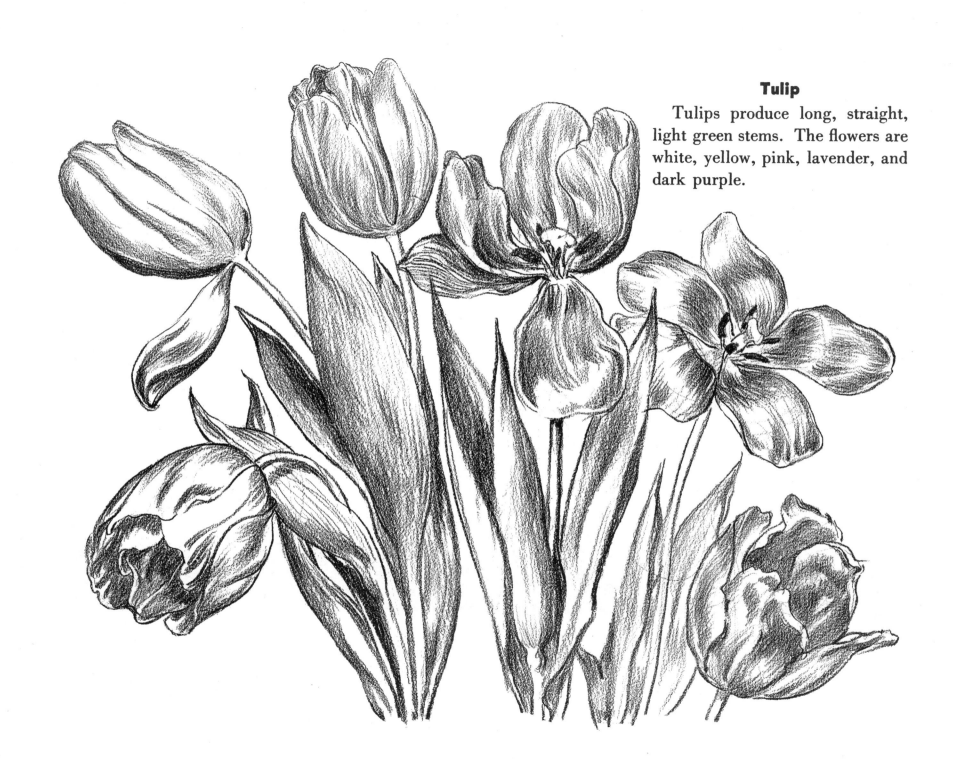

Tulip

Tulips produce long, straight, light green stems. The flowers are white, yellow, pink, lavender, and dark purple.

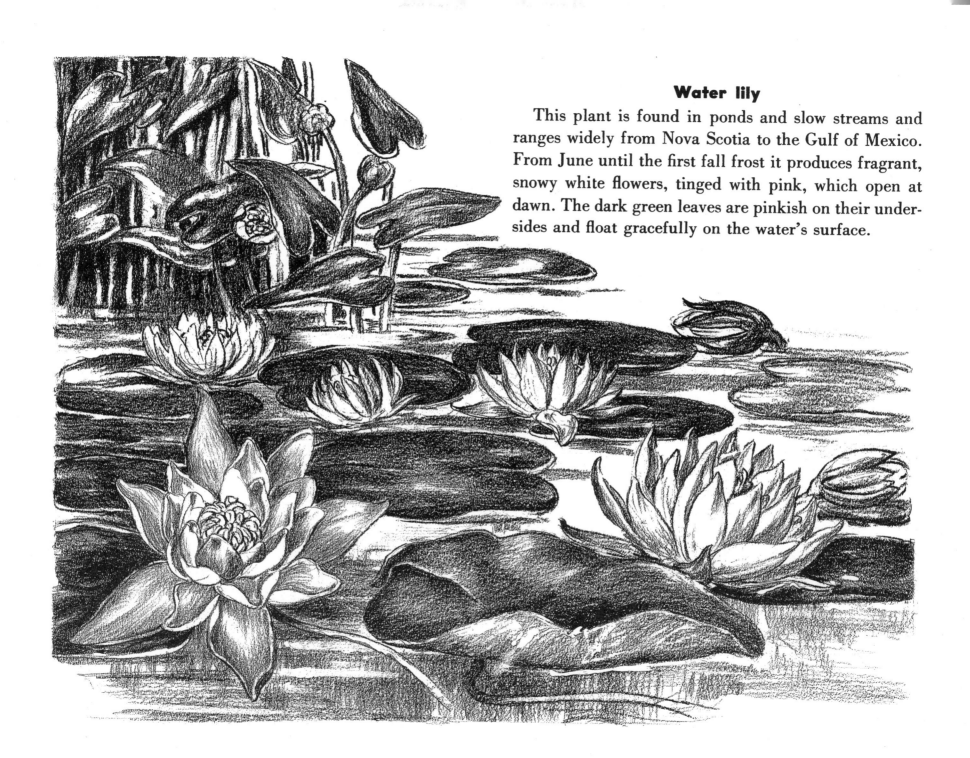

Water lily

This plant is found in ponds and slow streams and ranges widely from Nova Scotia to the Gulf of Mexico. From June until the first fall frost it produces fragrant, snowy white flowers, tinged with pink, which open at dawn. The dark green leaves are pinkish on their undersides and float gracefully on the water's surface.

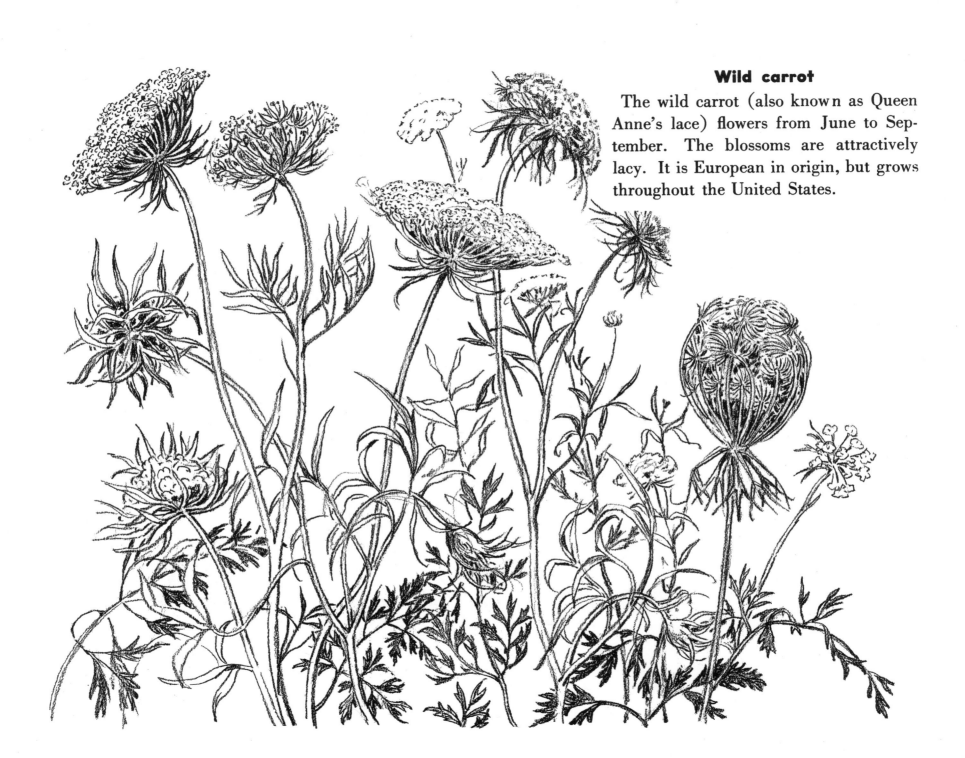

Wild carrot

The wild carrot (also known as Queen Anne's lace) flowers from June to September. The blossoms are attractively lacy. It is European in origin, but grows throughout the United States.

Wild tiger lily

There are several varieties of this hardy plant. The flowers are bright orange, some distinguished by red-brown spots. The brilliantly green leaves are long-pointed.

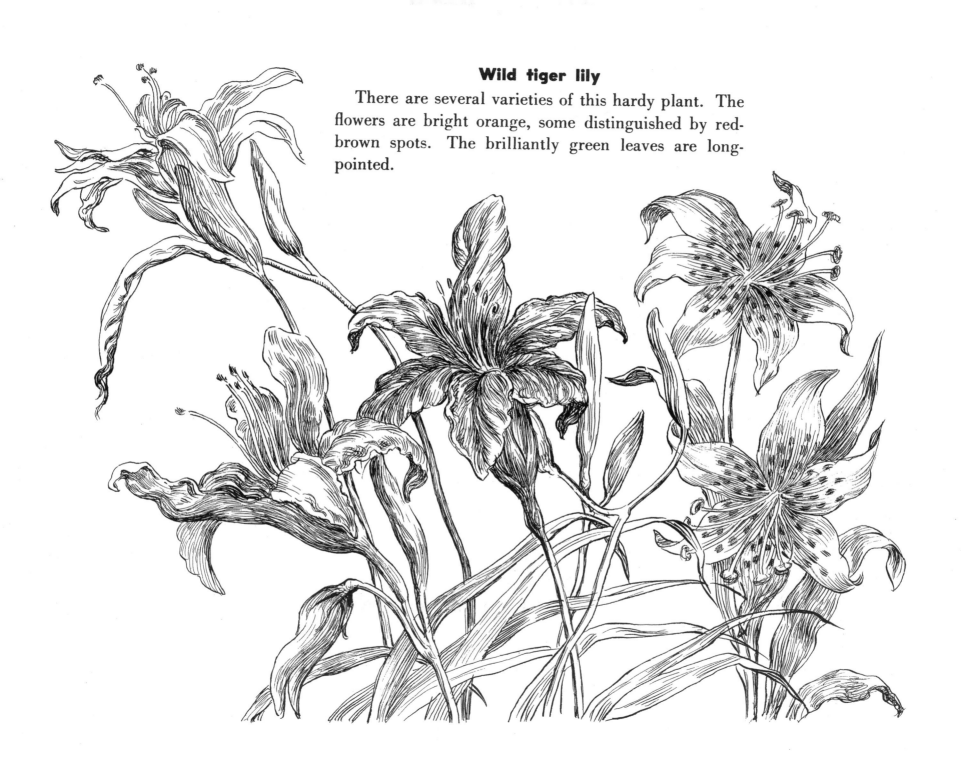

STATE FLOWERS

Alabama: goldenrod

Arizona: saguaro cactus

Arkansas: apple blossom

California: golden poppy

Colorado: columbine

Connecticut: mountain laurel

Delaware: peach blossom

Florida: orange blossom

Georgia: Cherokee rose

Idaho: syringa

Illinois: violet

Indiana: peony

Iowa: wild rose

Kansas: sunflower

Kentucky: goldenrod

Louisiana: magnolia grandiflora

Maine: pine cone

Maryland: black-eyed Susan

Massachusetts: Mayflower

Michigan: apple blossom

Minnesota: moccasin flower

Mississippi: magnolia grandiflora

Missouri: hawthorn

Montana: bitterroot

Nebraska: goldenrod

Nevada: sagebrush

New Hampshire: purple lilac

New Jersey: violet

New Mexico: yucca

New York: rose

North Carolina: dogwood

North Dakota: wild prairie rose

Ohio: scarlet carnation

Oklahoma: mistletoe

Oregon: Oregon grape

Pennsylvania: mountain laurel

Rhode Island: violet

South Carolina: yellow jessamine

South Dakota: pasqueflower

Tennessee: iris

Texas: bluebonnet

Utah: sego lily

Vermont: red clover

Virginia: American dogwood

Washington: rhododendron

West Virginia: rhododendron

Wisconsin: violet

Wyoming: Indian paint brush

District of Columbia: American beauty rose

Alaska: forget-me-not

Hawaii: red hibiscus